JUST ANOTHER DAY AT THE FNJOB

AN ADULT COLORING AND ACTIVITY BOOK

A.R. PERONA

If the copier jams or breaks, walk away. The repair fairy will get a psychic message to come fix it.

Glue snout on photo

Place photo here.

CREDIT HOG

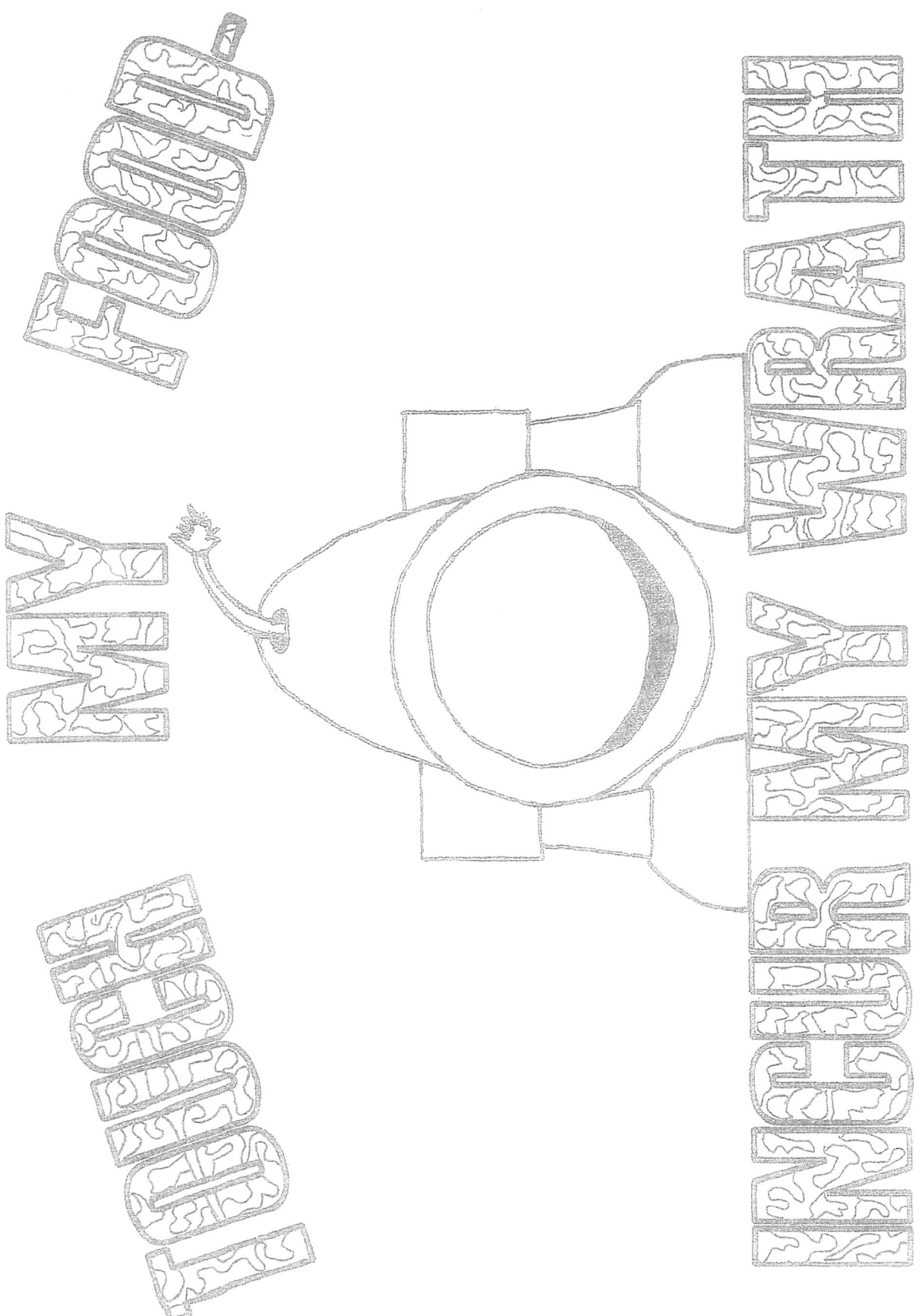

FUCK THIS SHIT

We all love the smell of burnt coffee.

Leave a trace in the pot with the burner on so we can all enjoy.

&

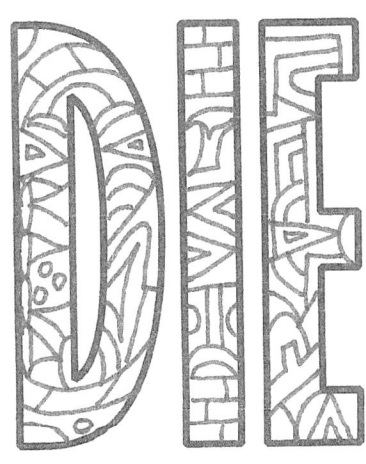

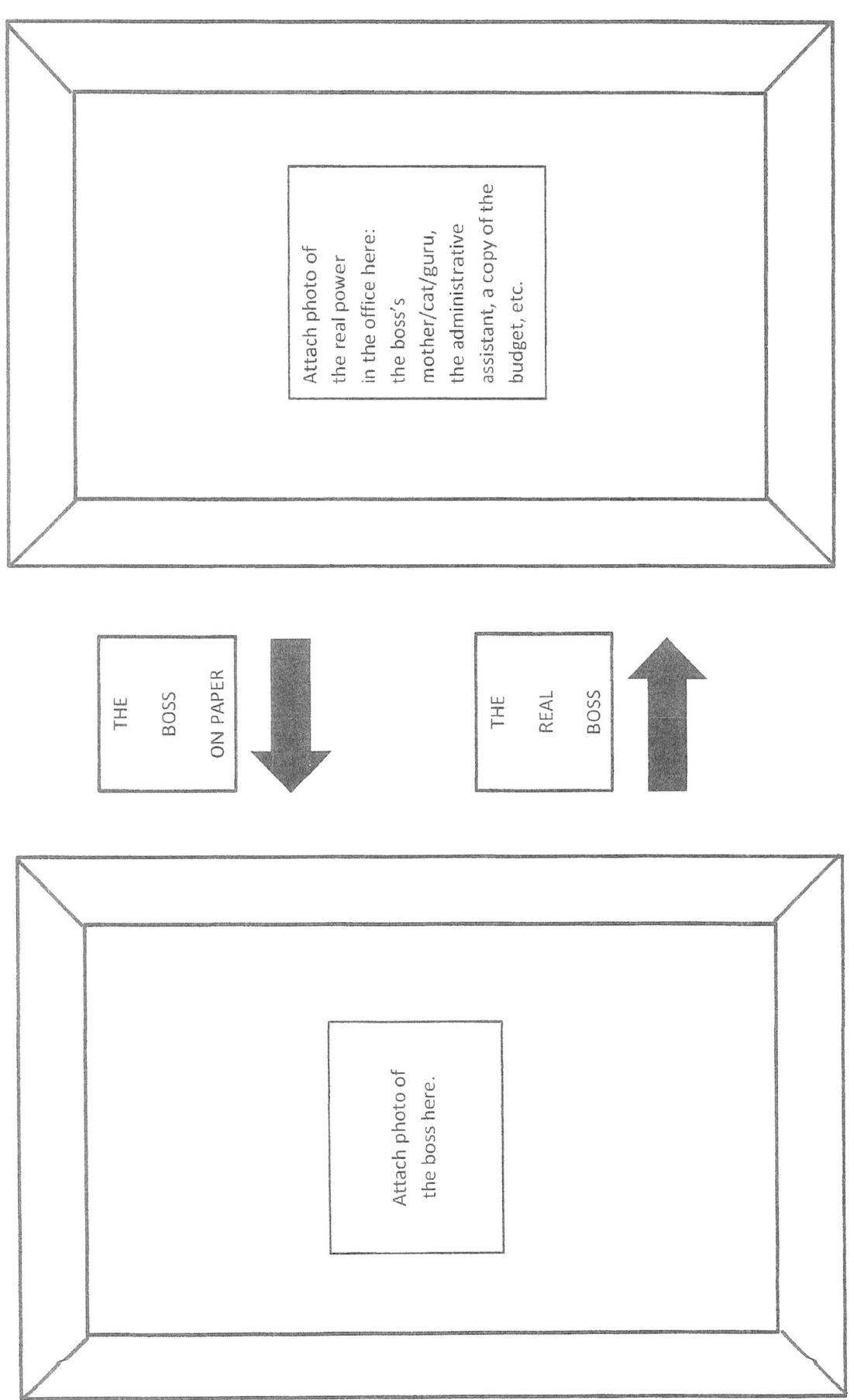

We all enjoy the smell of your:

1: burnt popcorn

2: reheated fish

3: _____

Thanks for sharing.

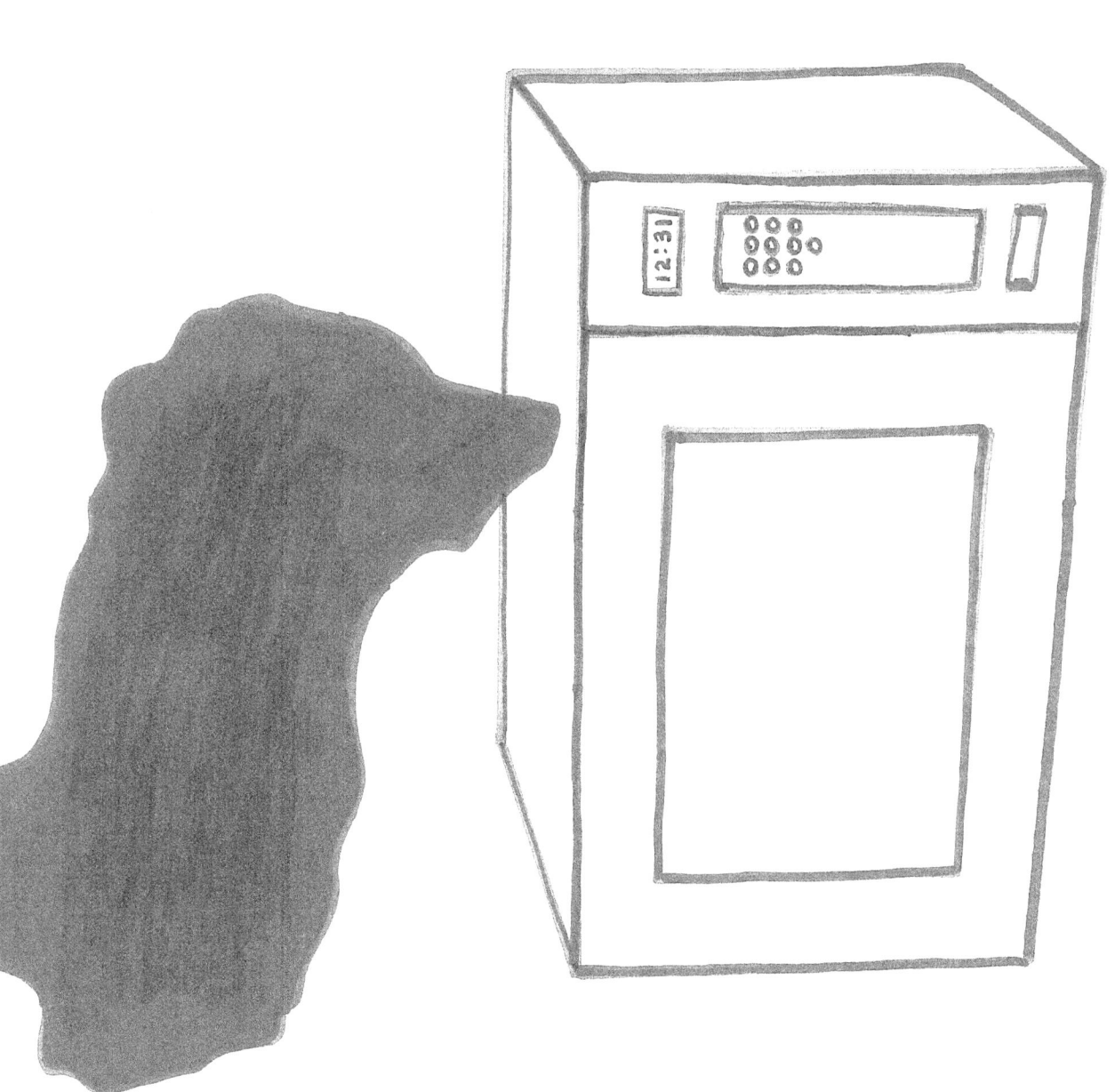

off to the fmjob.

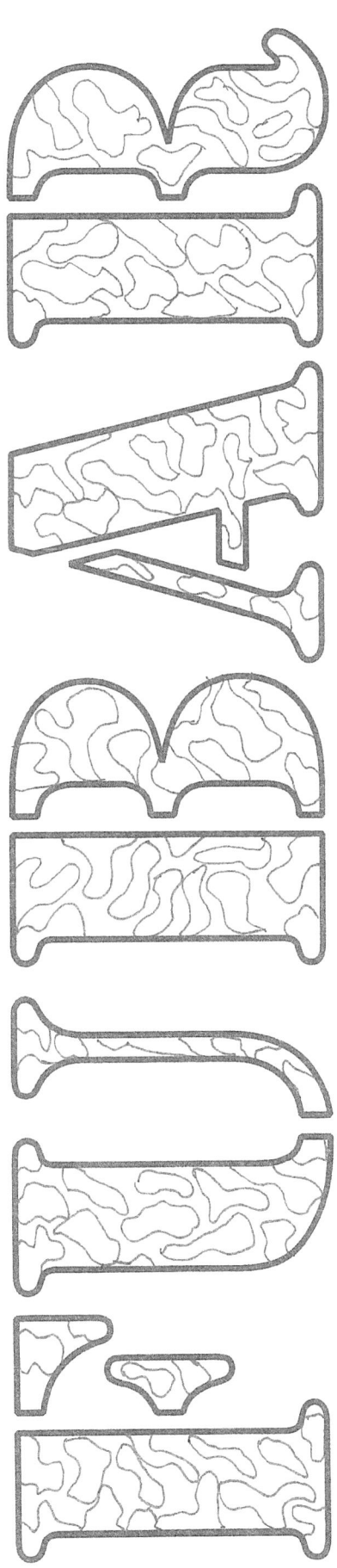

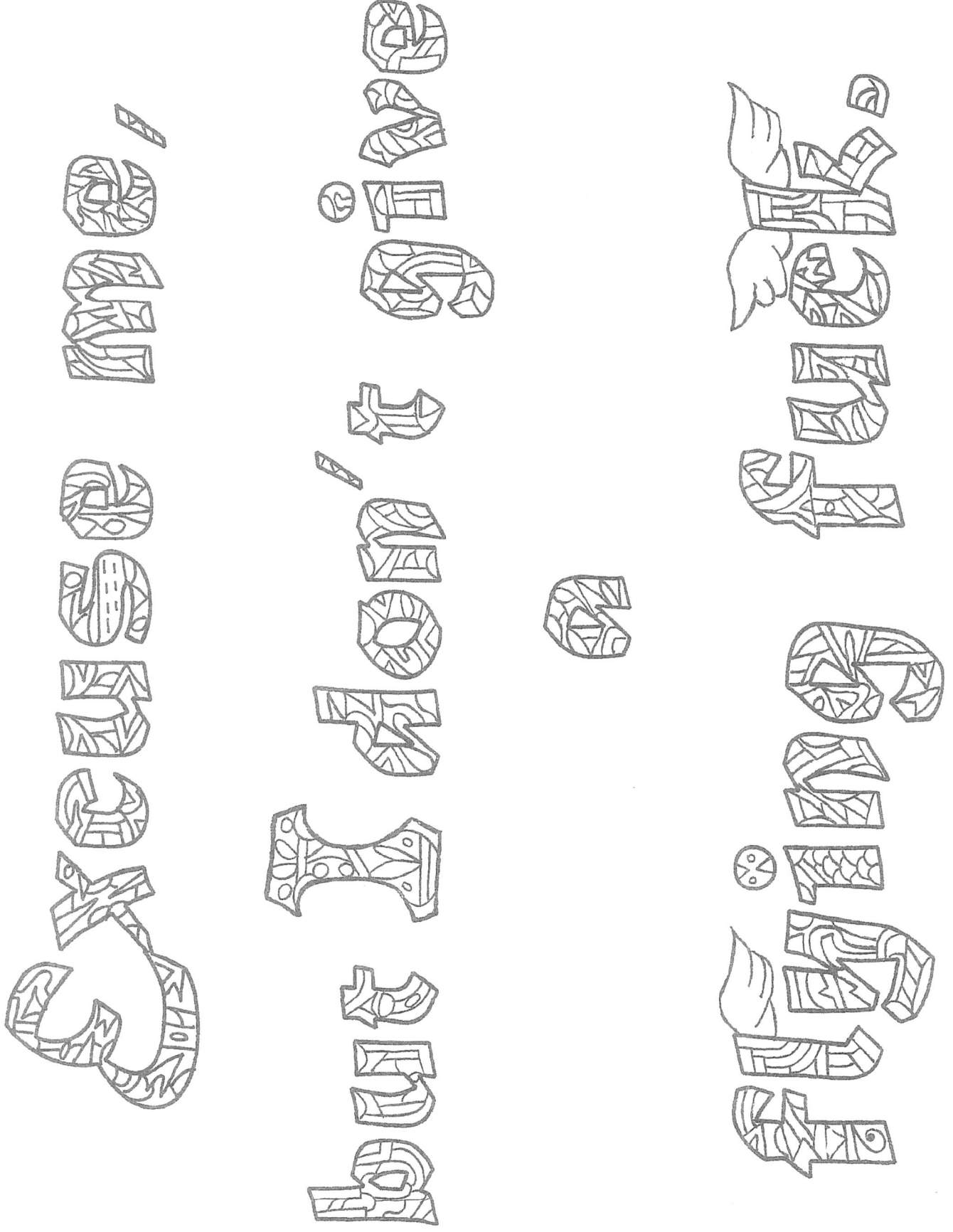

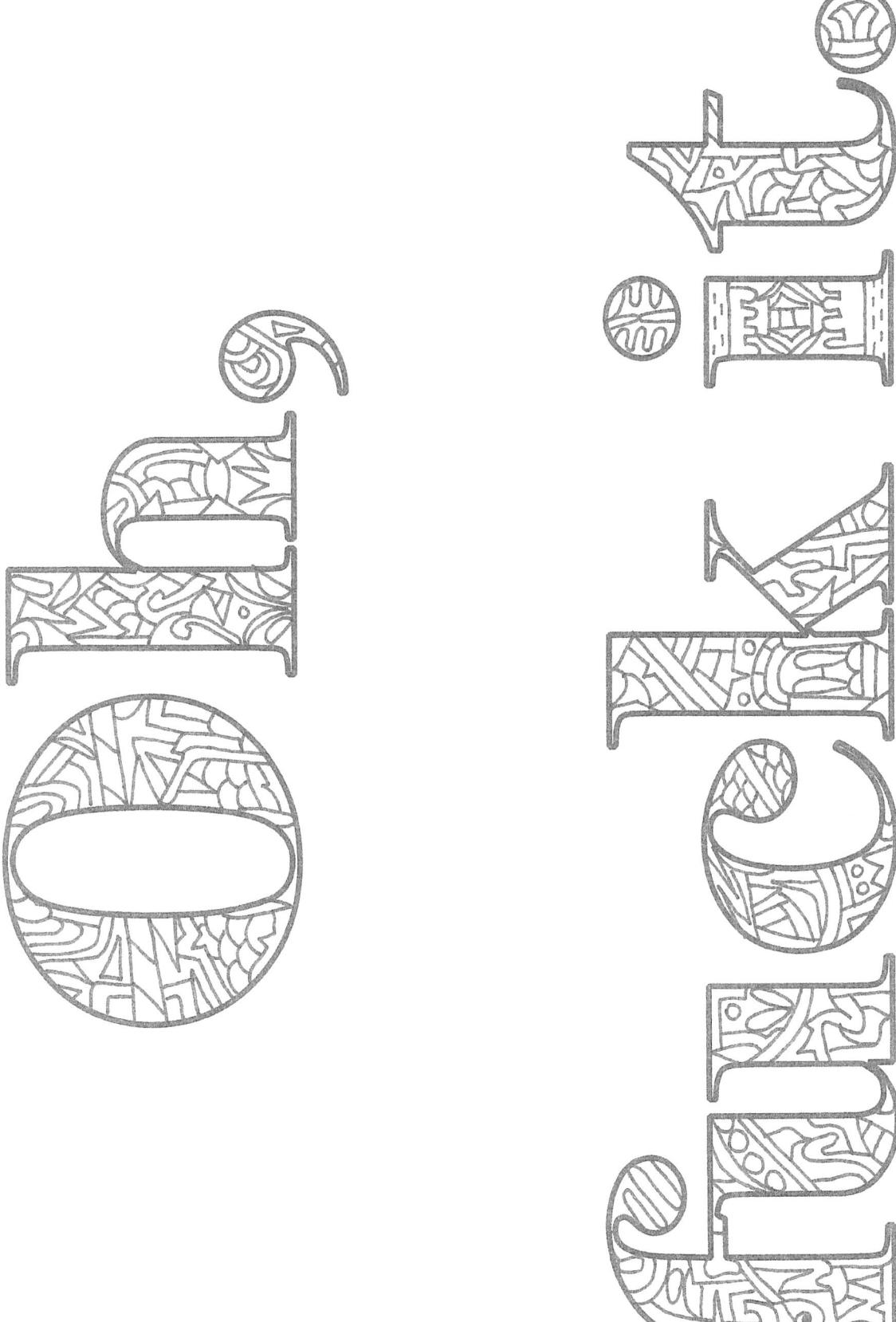

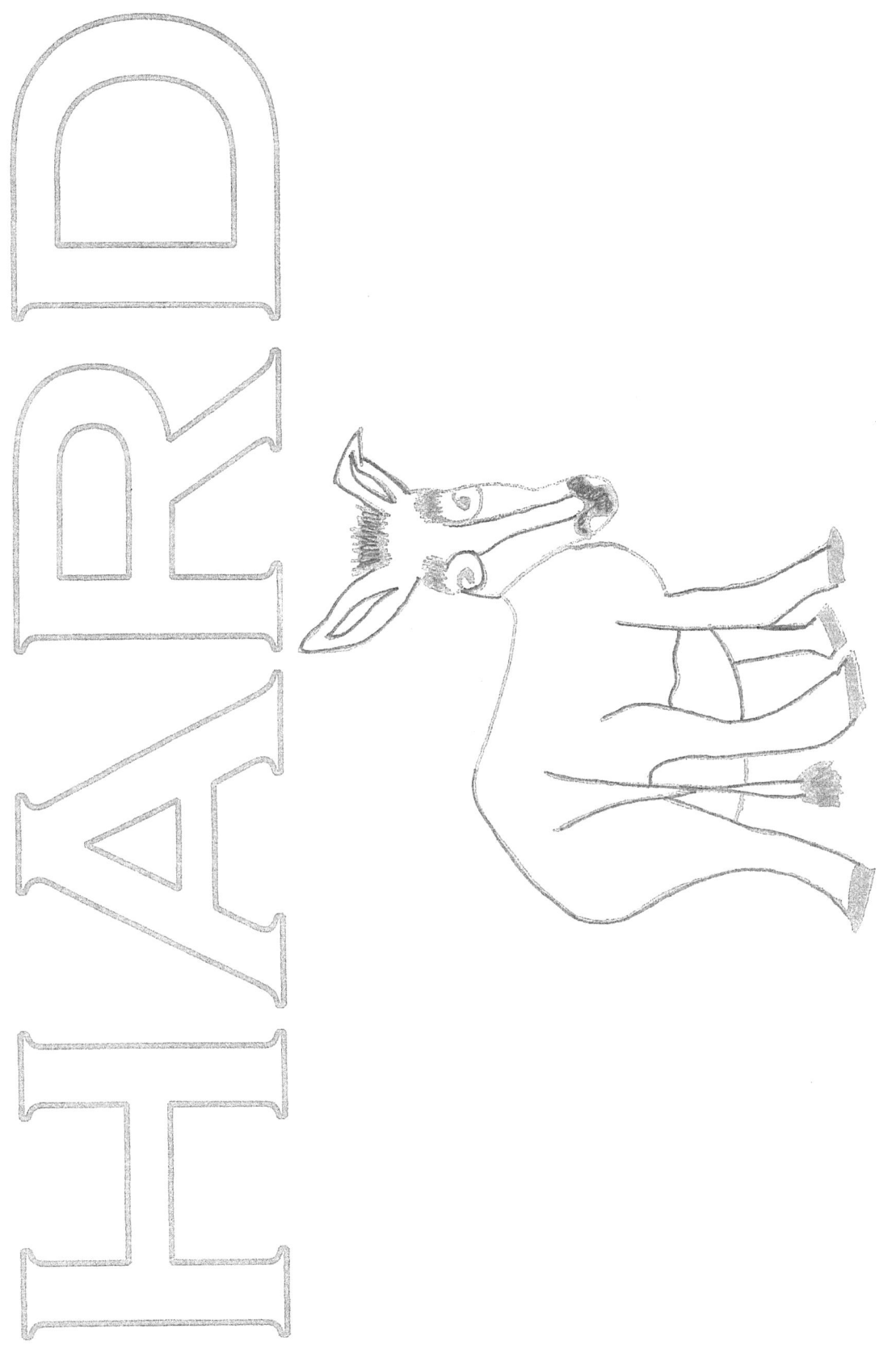

This is a shared area.

Your momma isn't here to clean up after you.
Neither are we.

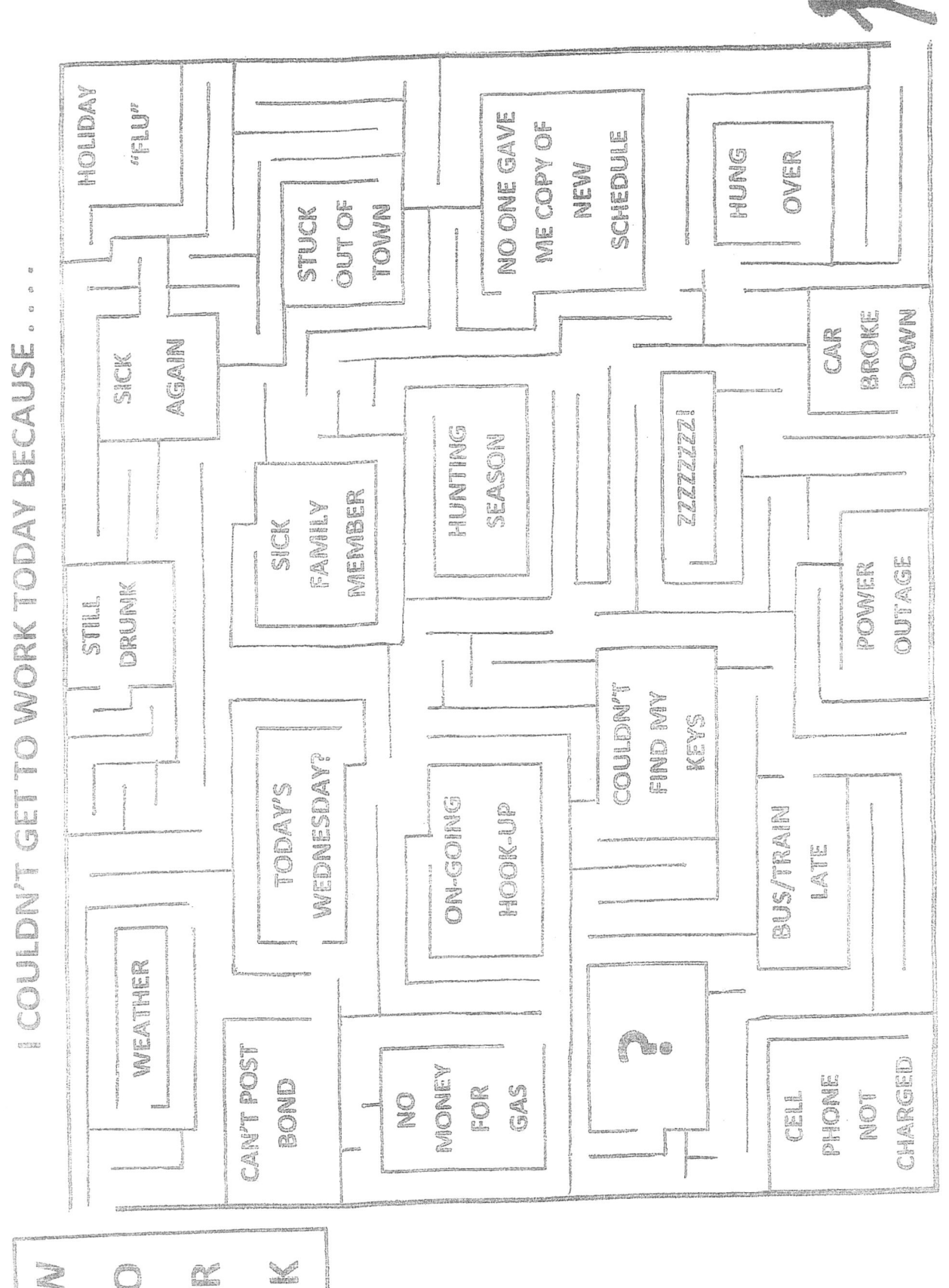

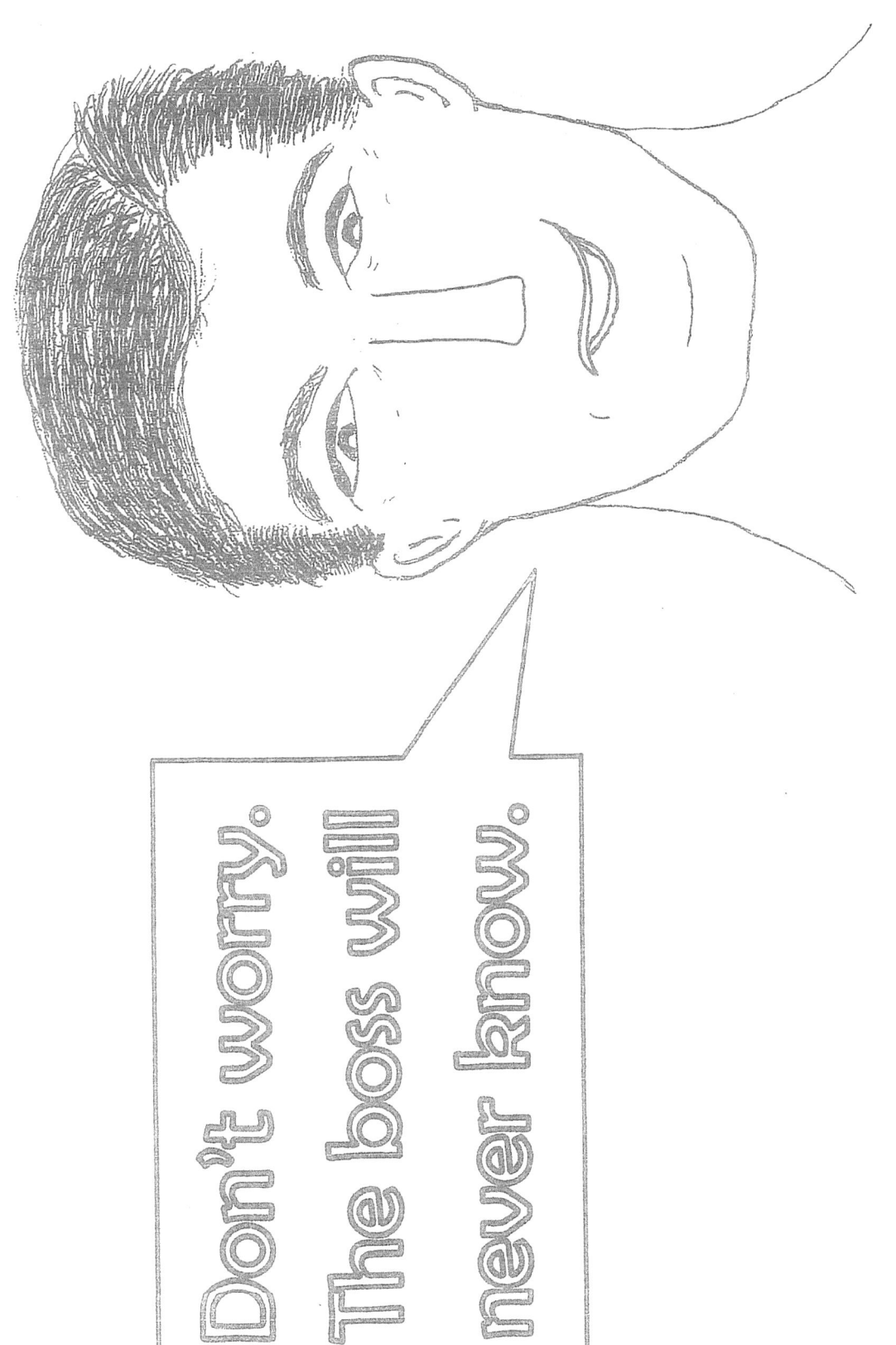

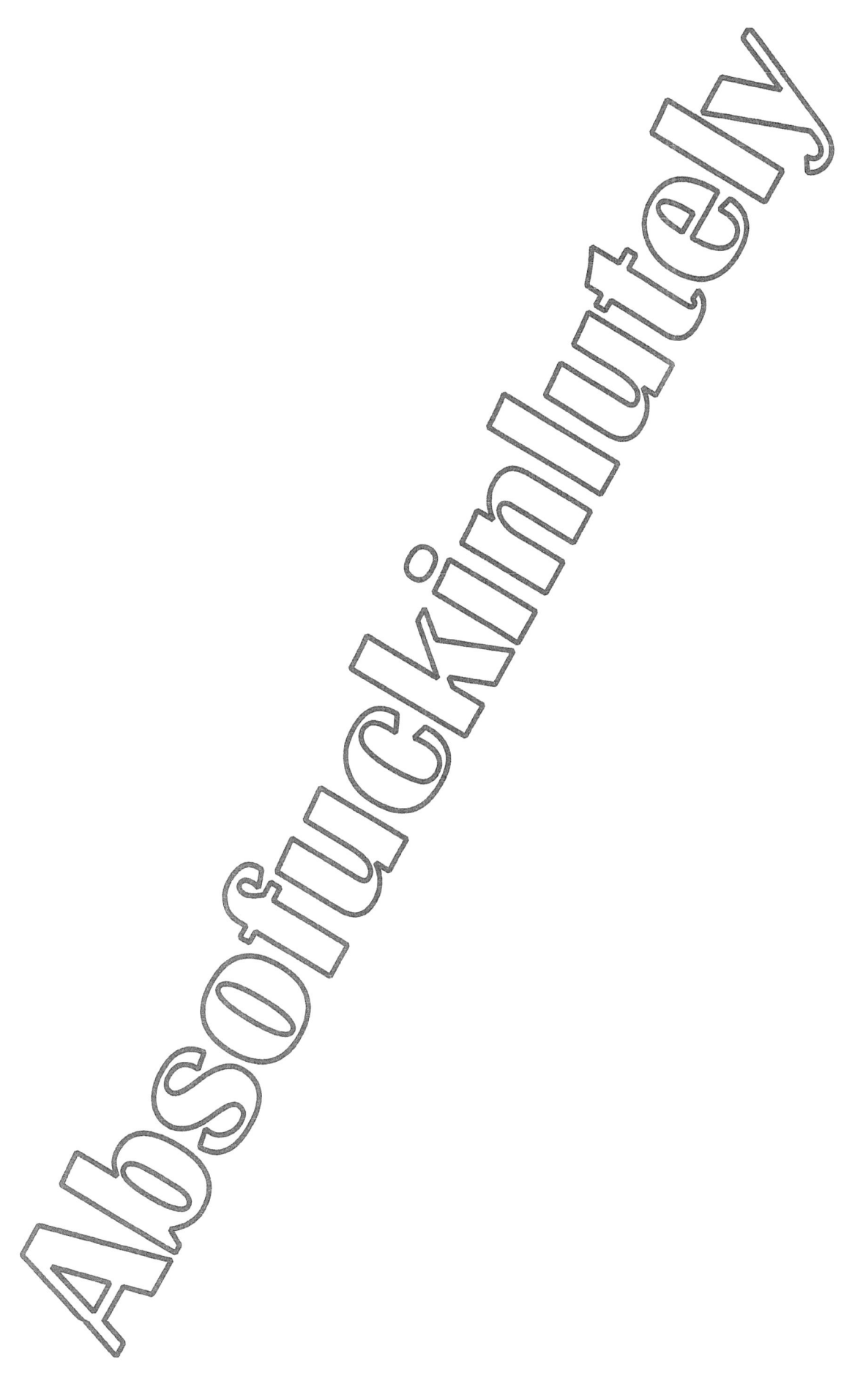

sweet job o' mine

Takeo Takei... job

www.ingramcontent.com/pod-product-compliance
Lightning Source LLC
Chambersburg PA
CBHW080551190526
45169CB00007B/2720